The
Artful Dog

Canines from The Metropolitan Museum of Art

CHRONICLE BOOKS
SAN FRANCISCO

THE METROPOLITAN MUSEUM OF ART • New York

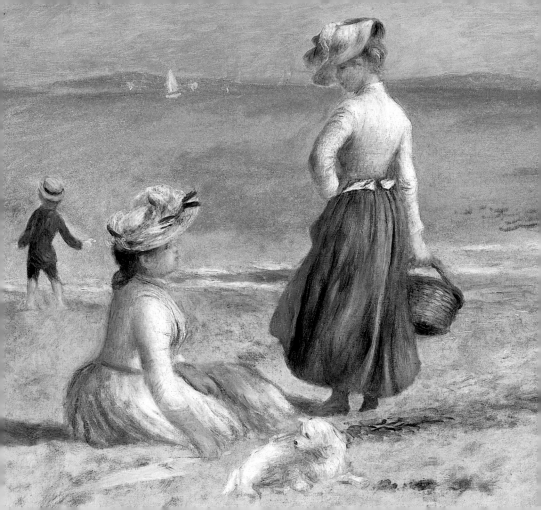

For thousands of years, humans and dogs have been the best of friends. How they came together we can only guess. James Thurber would have us believe that "the first man brought the first dog to his cave (no doubt over and above his wife's protests)," but, just as likely, the first woman, far from protesting, beckoned the first dog to sit by the fire. The first dog sat and stayed, and so captivated its audience that someone reached for a charred stick and artfully drew a sketch of the first dog—now the first pet—on the cave wall.

Whatever in fact happened, this we know for sure: A bond was formed that has been stronger than that between any other two species. Dogs have unabashedly attached themselves to us, and we to them. They give us unwavering loyalty and devotion, and we see in them the finest qualities that we possess: courage, steadfastness, and kindness. We love them. We are dog people.

Since that first person picked up a drawing tool, artists throughout the ages have shared our delight in dogs and have been inspired to capture their spirit, their beauty, their *dogness*. The dogs depicted in this book are of various sizes, shapes, colors, and breeds. They are charming, cheerful, intelligent, affectionate, dignified, feisty, and funny. Their portraits, paired with sayings by admirers and observers of canines, celebrate—with joy, humor, gusto, and reverence—our favorite animal.

—Shari Thompson

Figures on the Beach (detail). Pierre-Auguste Renoir, French, 1841–1919

Dogs are our link to paradise.
They don't know evil or jealousy
or discontent. To sit with a dog on
a hillside on a glorious afternoon is to
be back in Eden, where doing nothing
was not boring—it was peace.

Milan Kundera, Czech, b. 1929

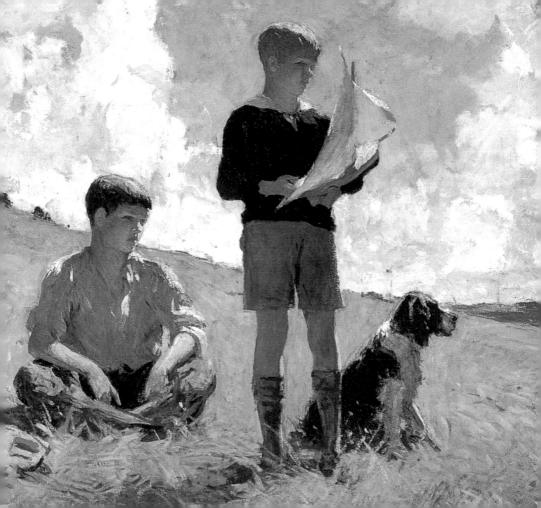

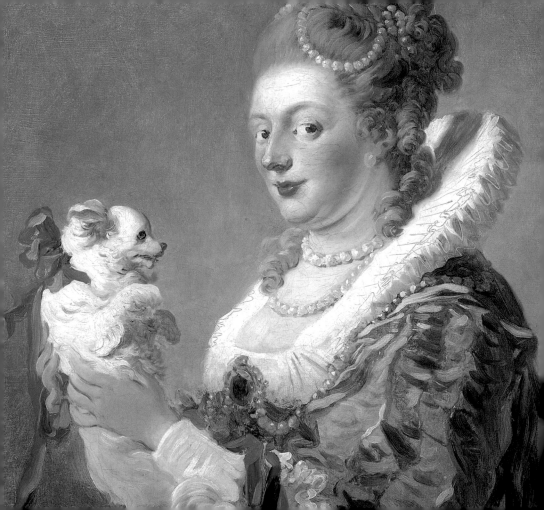

No one…appreciates the very special genius of your conversation as a dog does.

Christopher Morley, American, 1890–1957

Every dog is brave on his own doorstep.

Irish proverb

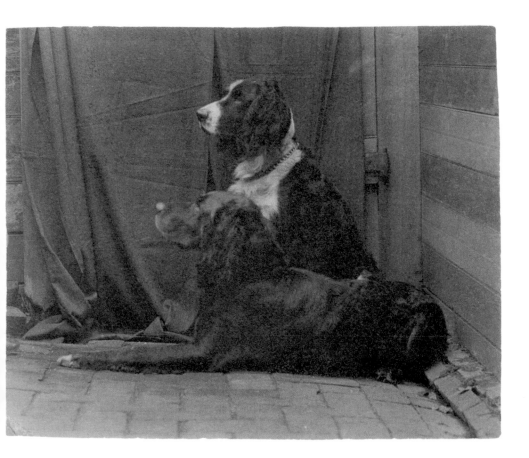

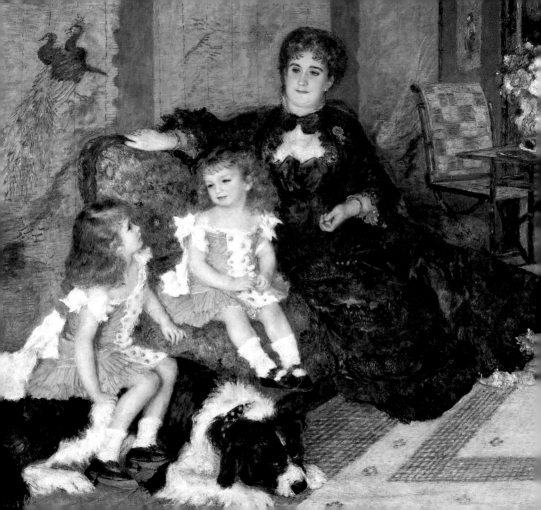

. . . Dogs have given us their absolute all. We are the center of their universe, we are the focus of their love and faith and trust. They serve us in return for scraps. It is without a doubt the best deal man has ever made.

Roger Caras, American, 1928–2001

The dog is man's best friend.
He has a tail on one end.
Up in front he has teeth.
And four legs underneath.

Ogden Nash, American, 1902–1971

A Limier Briquet Hound (detail). Rosa Bonheur, French, 1822–1899

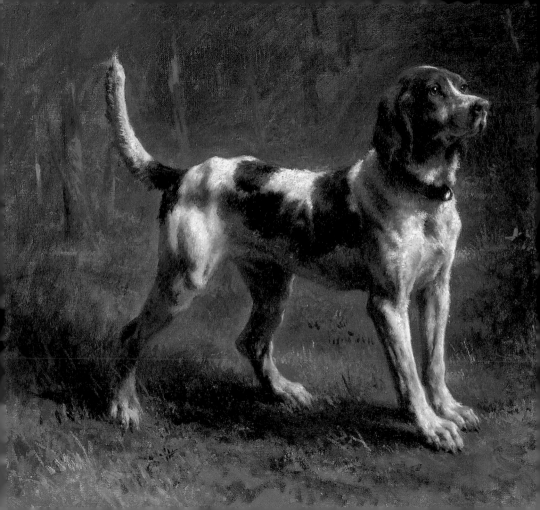

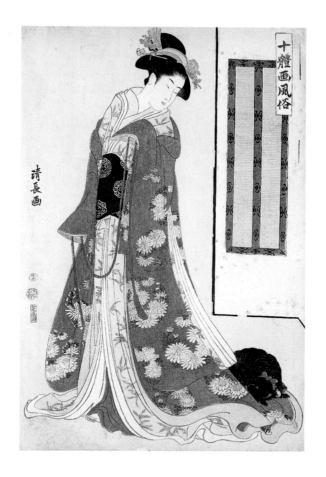

My little old dog:
A heart-beat
At my feet.

Edith Wharton, American, 1862–1937

Outside of a dog, a book is man's best friend.
Inside of a dog, it's too dark to read.

Groucho Marx, American, 1890–1977

The Artist's Wife and His Setter Dog. Thomas Eakins, American, 1844–1916

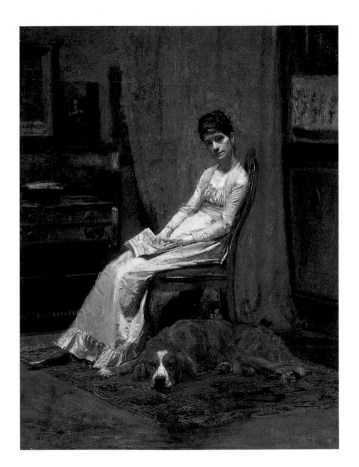

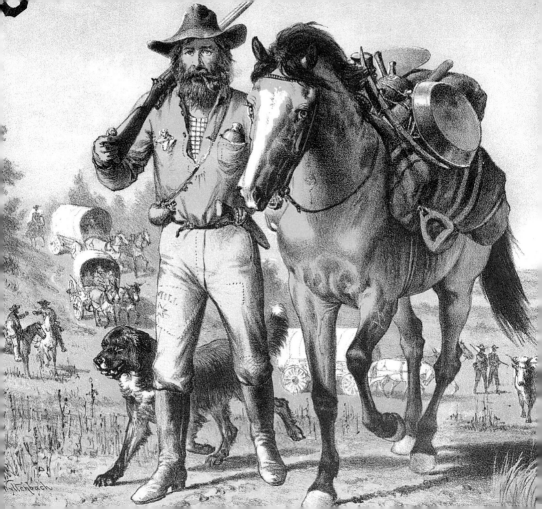

A really companionable and indispensable dog is an accident of nature. You can't get it by breeding for it, and you can't buy it with money. It just happens along.

E. B. White, American, 1899–1985

There is no man so poor but what
he can afford to keep one dog.

Josh Billings, American, 1818–1885

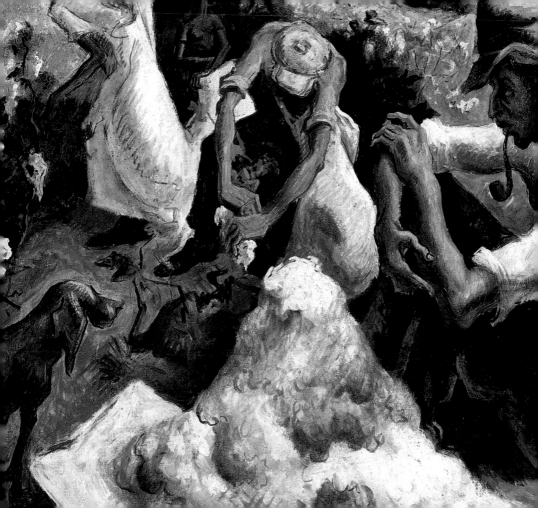

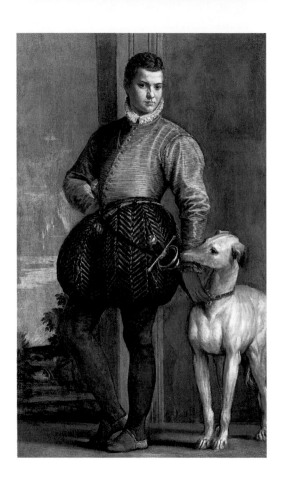

What feeling do we ever find
To equal among human kind
A dog's fidelity!

Thomas Hardy, English, 1840–1928

Boy with a Greyhound. Paolo Veronese (Paolo Caliari), Italian (Venetian), 1528–1588

Sir, he's a good dog and a fair dog.
Can there be more said?

William Shakespeare, English, 1564–1616

A Woman with a Dog (detail). Giacomo Ceruti, Italian (Lombard), 1698–1767

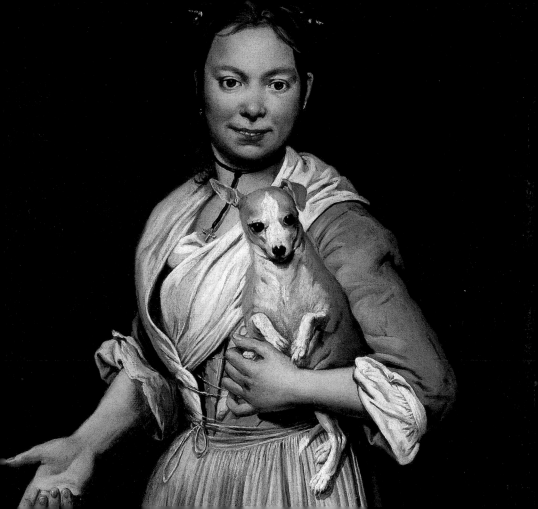

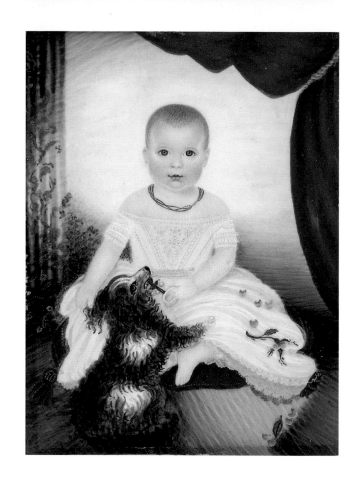

The dog was created specially for children. He is the god of frolic.

Henry Ward Beecher, American, 1813–1887

Baby with Rattle and Dog. Mrs. Moses B. Russell, American, 1809–1854

For it is by muteness that a dog becomes for one so utterly beyond value; with him one is at peace, where words play no torturing tricks.

John Galsworthy, English, 1867–1933

Woman with Collie (detail). John Singer Sargent, American, 1856–1925

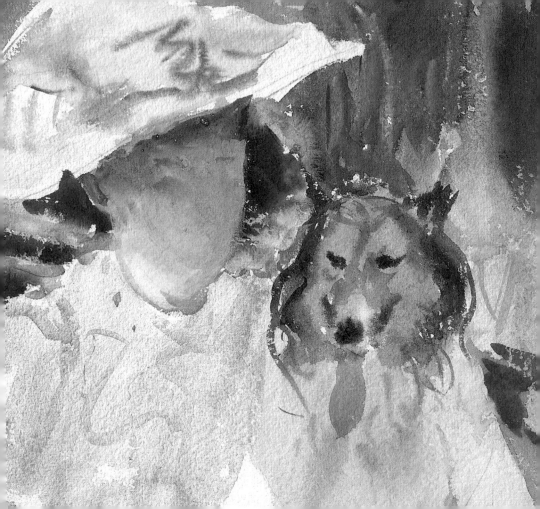

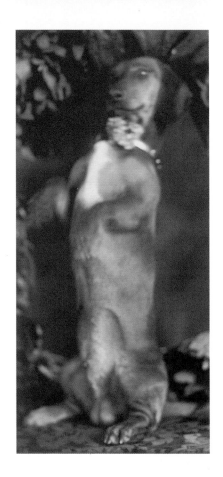

Dogs don't mind being photographed
in compromising situations.

Elliott Erwitt, American (b. France), b. 1928

.

Learning How to "Sit Up!" Frank Eugene, American, 1865–1936

If dogs are not there, it is not heaven.

Elizabeth Marshall Thomas, American, b. 1931

Diana and Cupid (detail). Pompeo Girolamo Batoni, Italian (Roman), 1708–1787

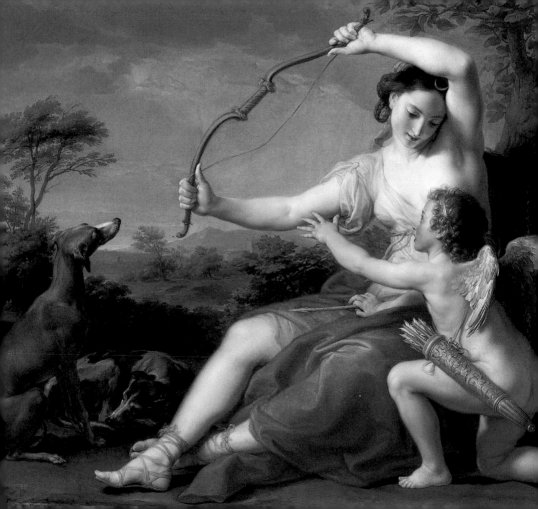

Rambunctious, rumbustious, delinquent dogs become angelic when sitting.

Ian Dunbar, English, b. 1947

I can say on firsthand authority
that poodles do not like brandy;
all they like is champagne and
they prefer it in a metal bowl.

James Thurber, American, 1894–1961

[*Walker Evans with Poodle*]. American, 1940s

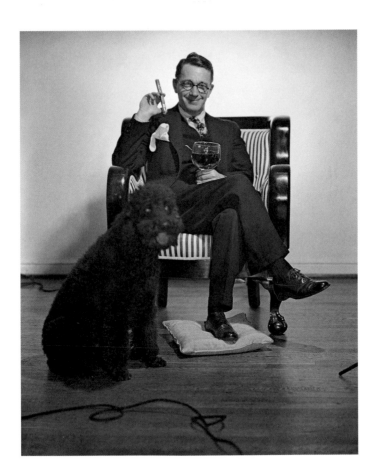

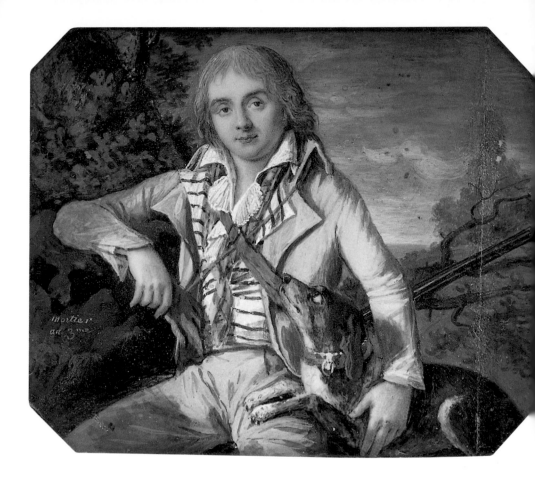

Don't accept your dog's admiration as conclusive evidence that you are wonderful.

Ann Landers, American, 1918–2002

A Hunter with a Dog. Mortier, French, active ca. 1790–1800

We are alone, absolutely alone on this chance planet; and amid all the forms of life that surround us, not one, excepting the dog, has made an alliance with us.

Maurice Maeterlinck, Belgian, 1862–1949

Approaching Thunder Storm (detail). Martin Johnson Heade, American, 1819–1904

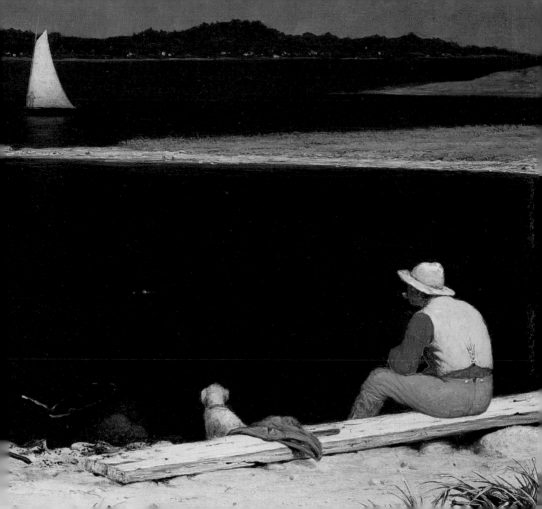

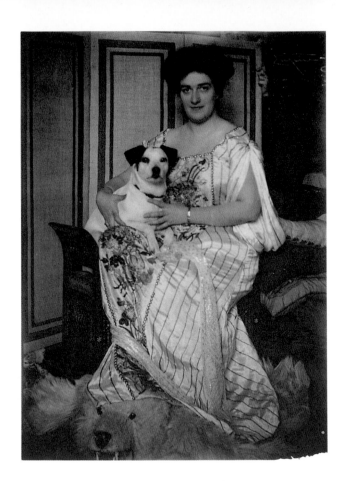

I am I because my little dog knows me.

Gertrude Stein, American, 1874–1946

The Diva and Her Most Trusty Friend and Companion. Frank Eugene, American, 1865–1936

The relationship between man and dog can often be as complex as that between man and woman.

Ian Niall, Scottish, 1916–2002

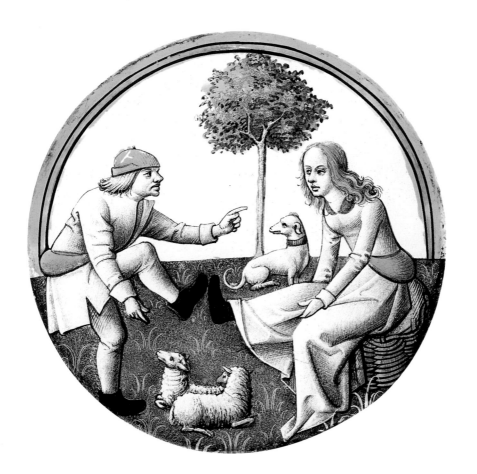

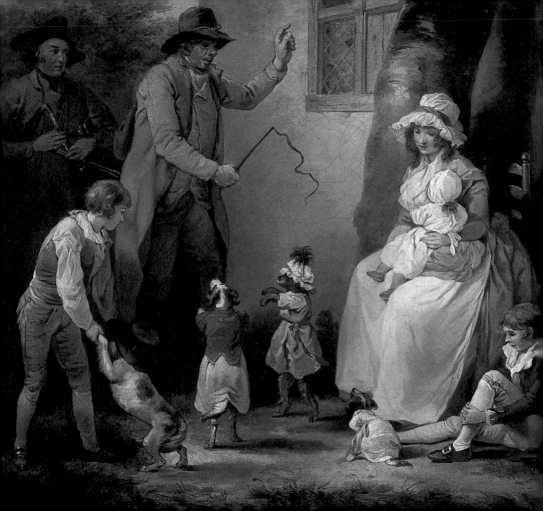

If you are a dog and your owner suggests that you wear a sweater... suggest that he wear a tail.

Fran Lebowitz, American, b. 1950

The Dancing Dogs (detail). George Morland, English, 1763–1804

Old dog Tray's ever faithful,
Grief cannot drive him away,
He's gentle, he is kind;
I'll never, never find
A better friend than old dog Tray.

Stephen Collins Foster, American, 1826–1864

Study of a Dog (detail). Sir Edwin Henry Landseer, English, 1802–1873

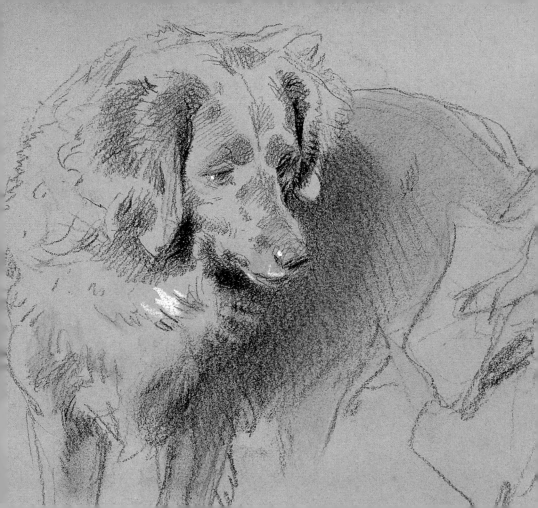

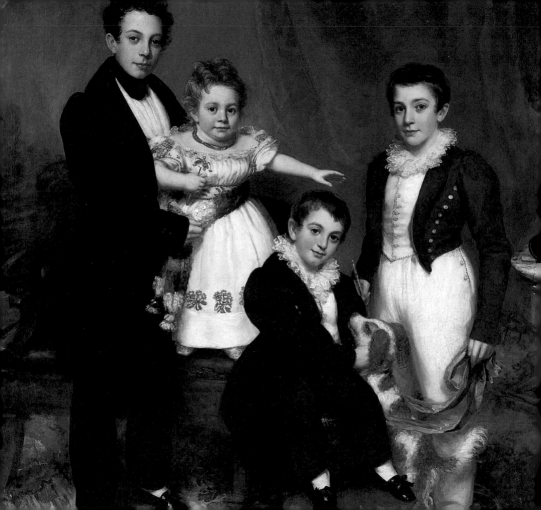

Blessings on thee, dog of mine,
Pretty collars make thee fine,
 Sugared milk make fat thee!
Pleasures wag on in thy tail,
Hands of gentle motion fail
 Nevermore, to pat thee!

Elizabeth Barrett Browning, English, 1806–1861

If you eliminate smoking and gambling, you will be amazed to find that almost all an Englishman's pleasures can be, and mostly are, shared by his dog.

George Bernard Shaw, Irish, 1856–1950

All Right! Nathaniel Currier, publisher, American, 1803–1887

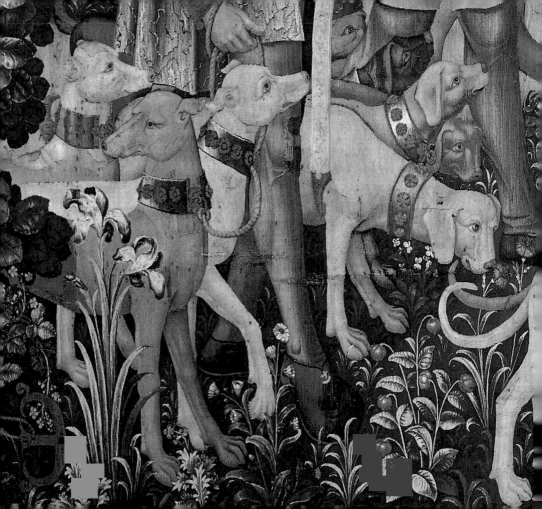

Despite the commotion, the greyhounds are silent. They are not given to the inelegant task of barking.

Susan Olasky, American, b. 1954

"Where are you going this nice fine day?"
(I said to the Puppy as he went by).
"Up in the hills to roll and play."
"I'll come with you, Puppy," said I.

A. A. Milne, English, 1882–1956

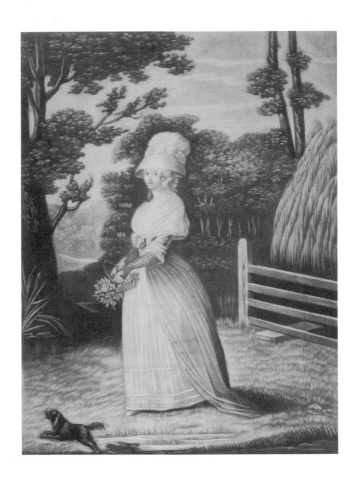

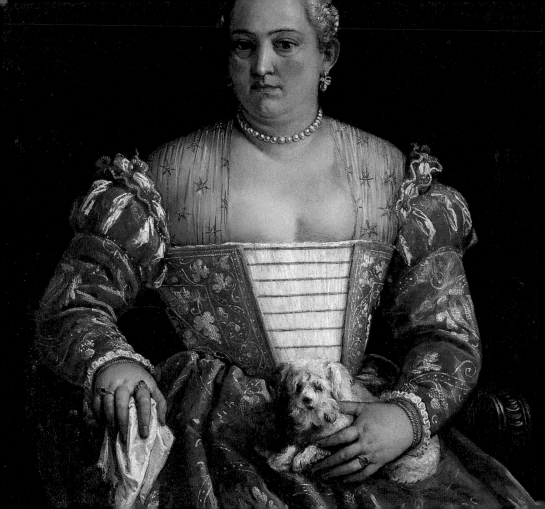

She had some little dogs, too, that she fed
On roasted flesh, or milk and fine white bread,
But sore she'd weep if one of them were dead,
Or if men smote it with a rod to smart;
For pity ruled her, and her tender heart.

Geoffrey Chaucer, English, ca. 1342–1400
(translation J. U. Nicolson)

I had rather see the portrait of a dog that I know, than all the allegorical paintings they can show me in the world.

Samuel Johnson, English, 1709–1784

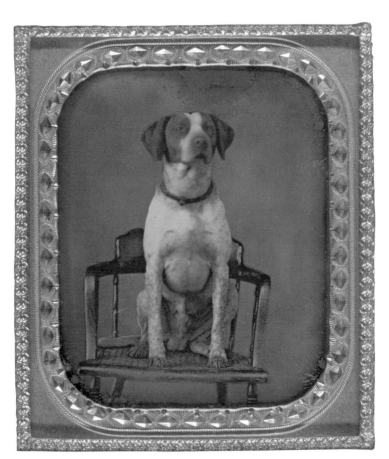

Dachshunds are ideal dogs for small children, as they are already stretched and pulled to such a length that the child cannot do much harm one way or the other.

Robert Benchley, American, 1889–1945

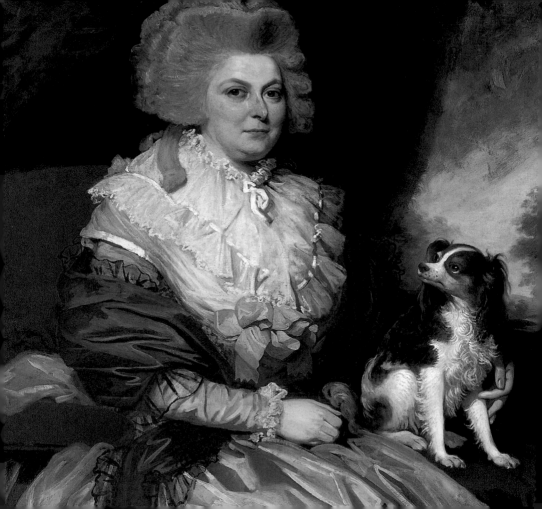

…Though parents, husbands, children, lovers, and friends are all very well, they are not dogs.

Elizabeth von Arnim, English (b. Australia), 1866–1941

I like a dog at my feet when I read,
Whatever his size or whatever his breed.

Edgar A. Guest, American (b. England), 1881–1959

Sir Walter Scott at Abbotsford (detail). English, third quarter of the 19th century

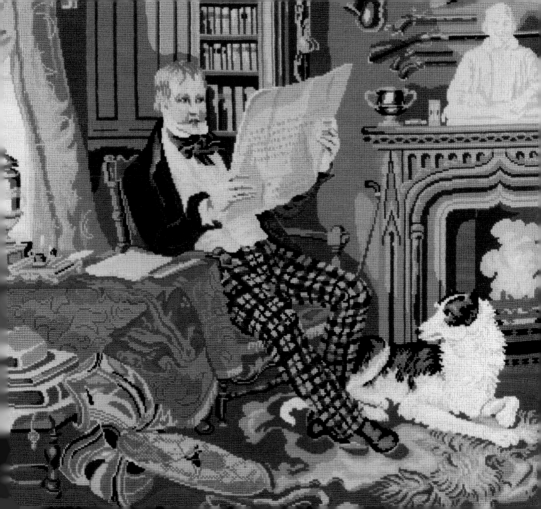

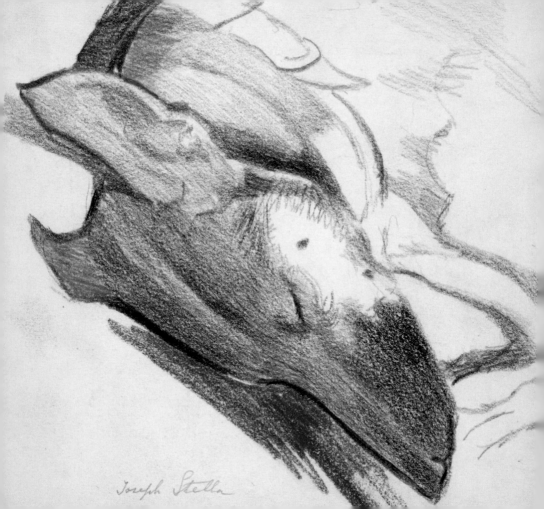

Joseph Stella

Let sleeping dogs lie—who wants to rouse 'em?

Charles Dickens, English, 1812–1870

Sleeping Dog (detail). Joseph Stella, American (b. Italy), 1877–1946

... What counts is not necessarily the size of the dog in the fight— it's the size of the fight in the dog.

Dwight D. Eisenhower, American, 1890–1969

Wild Dogs (detail). Leonard Koscianski, American, b. 1952

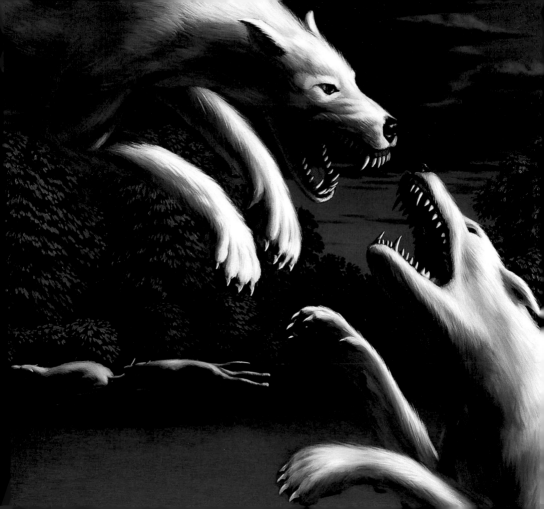

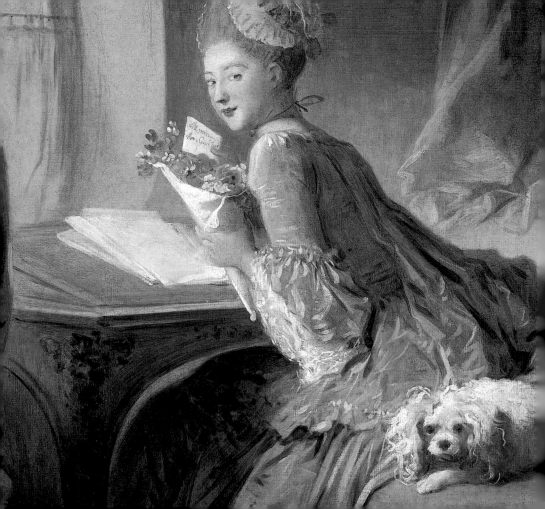

Who loves me loves my dog also.

St. Bernard de Clairvaux, French, 1090–1153

Happiness is a warm puppy.

Charles M. Schulz, American, 1922–2000

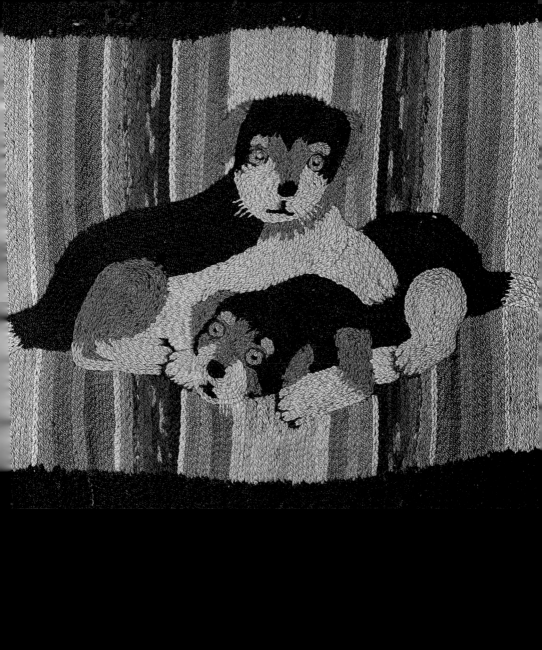

Credits

All of the works reproduced in this book are from the collections of The Metropolitan Museum of Art.

FRONT COVER
A Limier Briquet Hound (detail)
Rosa Bonheur, French, 1822–1899
Oil on canvas,
14½ x 18 in., ca. 1880
Catharine Lorillard Wolfe
Collection, Bequest of Catharine
Lorillard Wolfe, 1887 87.15.77

TITLE PAGE
Untitled
Anne Turyn, American, b. 1954
Chromogenic print,
12¹¹⁄₁₆ x 18½ in., 1983
Purchase, Charina Foundation Inc.
Gift, 1989 1989.1040.3

INTRODUCTION
Figures on the Beach (detail)
Pierre-Auguste Renoir, French,
1841–1919
Oil on canvas, 20¾ x 25¼ in.
Robert Lehman Collection, 1975
1975.1.198

Two Boys (detail)
Frank W. Benson, American,
1862–1951
Oil on canvas, 32³⁄₁₆ x 40⅛ in., 1926
George A. Hearn Fund, 1927 27.61

Portrait of a Woman with a Dog (detail)
Jean Honoré Fragonard, French,
1732–1806
Oil on canvas, 32 x 25¾ in., ca. 1769
Fletcher Fund, 1937 37.118

[*Thomas Eakins's Dog Harry and
Another Setter*]
Thomas Eakins, American,
1844–1916
Platinum print, 3⅜ x 4⅜ in., 1880s
Gift of John T. Marvin, 1985
1985.1027.11

*Madame Georges Charpentier (Marguerite-
Louise Lemonnier, 1848–1904) and
Her Children, Georgette-Berthe
(1872–1945), and Paul-Émile-Charles
(1875–1895)* (detail)
Pierre-Auguste Renoir, French,
1841–1919
Oil on canvas, 60½ x 74⅞ in., 1878
Catharine Lorillard Wolfe Collection,
Wolfe Fund, 1907 07.122

A Limier Briquet Hound (detail)
Rosa Bonheur, French, 1822–1899
Oil on canvas, 14½ x 18 in., ca. 1880
Catharine Lorillard Wolfe
Collection, Bequest of Catharine
Lorillard Wolfe, 1887 87.15.77

Woman with a Dog from the series
"Ten Stylish Types"
Torii Kiyonaga, Japanese, 1752–1815
Polychrome woodblock print,
14¾ x 9¹⁵⁄₁₆ in.
Fletcher Fund, 1929 JP1512

The Artist's Wife and His Setter Dog
Thomas Eakins, American,
1844–1916
Oil on canvas, 30 x 23 in., ca.
1884–89
Fletcher Fund, 1923 23.139

The Forty-Niner (detail)
Emanuel Wyttenbach, American,
active 1857–1894
Published by H. S. Crocker and Co.,
San Francisco
Color lithograph, advertisement for
Seal Rock Tobacco Co., 10½ x 10¼ in.,
after 1860
The Elisha Whittelsey Collection,
The Elisha Whittelsey Fund, 1948
48.120.251

Cotton Pickers, Georgia (detail)
Thomas Hart Benton, American,
1889–1975
Tempera and oil on canvas,
30 x 35¾ in., 1928–29
George A. Hearn Fund, 1933
33.144.2

Boy with a Greyhound
Paolo Veronese (Paolo Caliari),
Italian (Venetian), 1528–1588
Oil on canvas, 68⅜ x 40⅛ in.,
possibly 1570s
H. O. Havemeyer Collection,
Bequest of Mrs. H. O. Havemeyer,
1929 29.100.105

A Woman with a Dog (detail)
Giacomo Ceruti, Italian
(Lombard), 1698–1767
Oil on canvas, 38 x 28½ in., 1740s
Maria DeWitt Jesup Fund, 1930
30.15

Baby with Rattle and Dog
Mrs. Moses B. Russell, American,
1809–1854
Watercolor and gouache on ivory,
4½ x 3½, 1842
Purchase, The Overbrook
Foundation, Robert & Bobbie Falk
Philanthropic Fund, and Lois and
Arthur Stainman Philanthropic
Fund Gifts, 1999 1999.6

Woman with Collie (detail)
John Singer Sargent, American,
1856–1925
Watercolor, gouache, and graphite
on white wove paper,
13¹⁵⁄₁₆ x 9¹⁵⁄₁₆ in., after 1890
Gift of Mrs. Francis Ormond, 1950
50.130.27

Learning How to "Sit Up!"
Frank Eugene, American,
1865–1936
Platinum print, 3¾ x 1¾ in.,
ca. 1900s
Rogers Fund, 1972 1972.633.175

Diana and Cupid (detail)
Pompeo Girolamo Batoni, Italian
(Roman), 1708–1787
Oil on canvas, 49 x 68 in., 1761
Purchase, The Charles Engelhard
Foundation, Robert Lehman
Foundation Inc., Mrs. Haebler
Frantz, April R. Axton, L. H. P.
Klotz, and David Mortimer Gifts;
and Gifts of Mr. and Mrs. Charles
Wrightsman, George Blumenthal,
and J. Pierpont Morgan, Bequests of
Millie Bruhl Frederick and Mary
Clark Thompson, and Rogers Fund,
by exchange, 1982 1982.438

Take Sugar
Advertisement for the Great Atlantic
and Pacific Tea Company, American,
Chromolithograph, 6 x 8 in., 1880s
The Jefferson R. Burdick Collection,
Gift of Jefferson R. Burdick, Burdick
19, p.10v(1)

[*Walker Evans with Poodle*]
American, 1940s
Film negative, 4 x 5 in.
Walker Evans Archive, 1994
1994.254.136

A Hunter with a Dog
Mortier, French, active ca. 1790–1800
Ivory, 2¾ x 3¼ in., 1794–95
Gift of Mrs. Louis V. Bell, in memory
of her husband, 1925 25.106.15

Approaching Thunder Storm (detail)
Martin Johnson Heade, American,
1819–1904
Oil on canvas, 28 x 44 in., 1859
Gift of Erving Wolf Foundation
and Mr. and Mrs. Erving Wolf,
1975 1975.160

*The Diva and Her Most Trusty Friend
and Companion*
Frank Eugene, American, 1865–1936
Platinum print, 6¹¹⁄₁₆ x 4¹⁄₁₆ in.,
1890s–1910s
Alfred Stieglitz Collection, 1933
33.43.381

Roundel, Playing at Quintain
French, ca. 1500s
Colorless glass, silver stain, vitreous
paint, D. 8 in.
The Cloisters Collection, 1980
1980.223.6

The Dancing Dogs (detail)
George Morland, English, 1763–1804
Oil on canvas, 30 x 25⅛ in., ca. 1790
Gift of Evander B. Schley, 1951
52.116

Study of a Dog (detail)
Sir Edwin Henry Landseer, English,
1802–1873
Black chalk heightened with white
and red chalk, 6¹⁵⁄₁₆ x 9¾ in.
Bequest of Mary Cushing Fosburgh,
1978 1979.135.9

The Knapp Children (detail)
Samuel Lovett Waldo, American,
1783–1861; William Jewett,
American, 1792–1874
Oil on canvas, 70 x 57½ in., ca.
1833–34
Gift of Mrs. John Knapp Hollins, in
memory of her husband, 1959
59.114

All Right!
Nathaniel Currier, publisher,
American, 1803–1887
Hand-colored lithograph,
13⅝ x 8¹³⁄₁₆ in.
Bequest of Adele S. Colgate, 1962
63.550.449

The Hunt of the Unicorn (detail)
South Netherlandish, ca. 1495–1505
Wool warp, wool, silk, silver, and
gilt wefts, 12 ft. 1 in. x 12 ft. 9 in.
Gift of John D. Rockefeller Jr., 1937
37.80.5

The Fair Quaker
Robert Sayer, publisher, English,
1725–1793
Mezzotint, 13 x 9⅞ in., published
July 11, 1787
Gift of Mrs. Orme Wilson, 1963
63.533.2

Portrait of a Woman (detail)
Francesco Montemezzano, Italian
(Venetian), b. ca. 1540–d. after 1602
Oil on canvas, 46¾ x 39 in.,
H. O. Havemeyer Collection,
Bequest of Mrs. H. O. Havemeyer,
1929 29.100.104

[*Dog Posing for Portrait in Photographer's
Studio Chair*]
Rufus Anson, American, active 1850s
Daguerreotype, 3¼ x 2¾ in., ca. 1855
Funds from various donors, 2004
2004.219

Nain (detail)
Lucien Laforge, French, b. ca. 1885–?
From *ABC*, published by Henri
Goulet, Paris
Color woodcut, 11⁵⁄₁₆ x 9⁵⁄₁₆ in.
Harris Brisbane Dick Fund, 1930
30.96.7

Lady with a Dog (detail)
Mather Brown, American, 1761–1831
Oil on canvas, 49½ x 39½ in., 1786
Purchase, The Bertram F. and Susie
Brummer Foundation Inc. Gift,
1964 64.129

Sir Walter Scott at Abbotsford (detail)
English, third quarter of the
19th century
Wool, canvas, 27½ x 20¼ in.
Bequest of Caroline Mildreth Worth
Pinkham, in memory of Caroline
Amelia Worth, 1984 1985.62

Sleeping Dog (detail)
Joseph Stella, American (b. Italy),
1877–1946
Crayon and charcoal on paper,
11¼ x 9⅝ in., ca. 1921–26
Gift of Professor Irma B. Jaffe, in
honor of Richard York, 2002
2002.288

Wild Dogs (detail)
Leonard Koscianski, American,
b. 1952
Oil on canvas, 72 x 48 in., 1982
Gift of Karl Bornstein, 1984
1984.222

The Love Letter (detail)
Jean Honoré Fragonard, French,
1732–1806
Oil on canvas, 32¾ x 26⅜ in., ca. 1770
The Jules Bache Collection, 1949
49.7.49

Carpet (detail)
Zeruah H. Guernsey Caswell,
American, 1805–ca. 1895
Wool, embroidered in chain stitch,
13 x 12¼ in., 1832–35
Gift of Katharine Keyes, in memory
of her father, Homer Eaton Keyes,
1938 38.157

BACK FLAP
[*Adolph de Meyer and His Dog*]
Unknown artist, unknown school,
1905–10
Gelatin silver print, 3¼ x 3¼ in.
Gift of Lunn Gallery, 1980
1980.1128.14

BACK COVER
The Love Letter
Jean Honoré Fragonard, French,
1732–1806
Oil on canvas, 32¾ x 26⅜ in., ca. 1770
The Jules Bache Collection, 1949
49.7.49

Library of Congress Cataloging-in-Publication Data:

The artful dog : canines from the Metropolitan Museum of Art.
 p. cm.
ISBN-10: 0-8118-5541-4 (Chronicle) ISBN-13: 978-0-8118-5541-9 (Chronicle) ISBN-10: 1-58839-179-5 (MMA)
1. Dogs in art. 2. Dogs—Quotations, maxims, etc. 3. Art—New York
(State)—New York. 4. Metropolitan Museum of Art (New York, N.Y.) I.
Metropolitan Museum of Art (New York, N.Y.)
 N7668.D6A78 2006
 704.9'432977200747471—dc22

 2005034246

Manufactured in China.

ENDPAPERS AND COPYRIGHT PAGE: Thorne, Diana. *Drawing Dogs.* New York, The Studio Publications, Inc., (1940).
Thomas J. Watson Library, The Metropolitan Museum of Art.

Work by Thomas Hart Benton © T. H. Benton and R. P. Benton Testamentary Trusts/UMB Bank Trustee/Licensed by VAGA, New York, New York.

Excerpt by A. A. Milne, from "Puppy and I," from *When We Were Very Young,* illustrations by E. H. Shepard, ©1924 by E. P. Dutton, renewed 1952 by A. A.
Milne. Used by permission of Dutton Children's Books, A Division of Penguin Young Readers Group, A Member of Penguin Group (USA) Inc., 345
Hudson Street, New York, New York 10014. All rights reserved.

Excerpt by Ogden Nash, from "The Dog" © 1957 by Ogden Nash. Reprinted by permission of Curtis Brown, Ltd.

Excerpt by E. B. White, from "Dog Training," from *One Man's Meat,* © 1940 by E. B. White. Copyright renewed. Reprinted by permission of Tilbury House,
Publishers, Gardiner, Maine.

Produced by the Department of Special Publications, The Metropolitan Museum of Art: Robie Rogge, Publishing Manager;
Jessica Schulte, Project Editor; Anna Raff, Designer; Mary Wong, Production Associate.
All photography by The Metropolitan Museum of Art Photograph Studio unless otherwise noted.

Edited by Shari Thompson

Visit the Museum's website: www.metmuseum.org

Distributed in Canada by Raincoast Books
9050 Shaughnessy Street
Vancouver, British Columbia, V6P 6E5

10 9 8 7 6 5 4 3 2 1

Chronicle Books LLC
85 Second Street
San Francisco, California 94105

www.chroniclebooks.com